DOGS
DRAW AND COLOR

JOHN GREEN

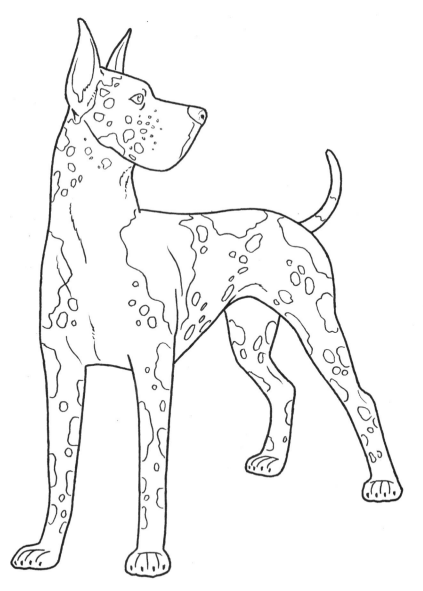

DOVER PUBLICATIONS, INC.
MINEOLA, NEW YORK

Bibliographical Note

Dogs Draw and Color is a new work, first published by
Dover Publications, Inc., in 2015.

International Standard Book Number

ISBN-13: 978-0-486-79799-1
ISBN-10: 0-486-79799-6

Manufactured in the United States by Courier Corporation
79799601 2015
www.doverpublications.com

HOW TO USE THIS BOOK

This book provides you with step-by-step instructions for drawing your own dogs. Following the blue lines in each of the easy instructional illustrations will show you exactly what to add to your drawing, and accompanying captions explain the process. There is also a completed black-and-white, full page line drawing of each dog for you to use to experiment with different media and color techniques. When you are ready to begin drawing your own dogs, turn to the back of the book, where you will find practice pages. The practice pages are perforated for easy removal and display.

You can shade your completed drawings with pencil or graphite, or color them in with colored pencil, pastels, markers, or paints. Before you begin, you may wish to experiment with both soft and hard lead pencils on a piece of scrap paper to find what suits your taste.

BEAGLE

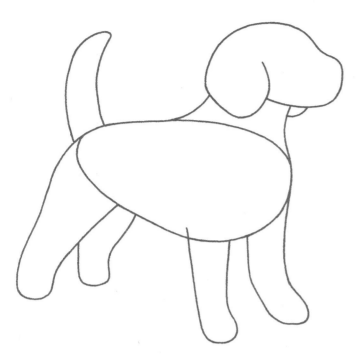

1. Draw a pear shape for the body and add lines for the neck. Outline the head and ears. Draw elongated oval shapes for the legs with rounded ends, making the front legs slightly longer than the rear. Add a shape for the tail.

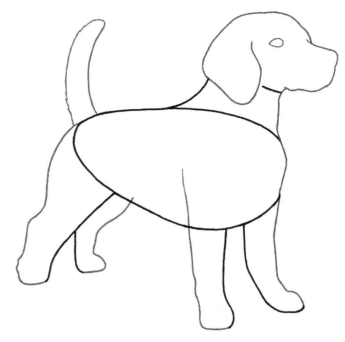

2. Refine the outline of the head and ears, and add a shape for the eye. Add definition to neck, chest, legs, and tail.

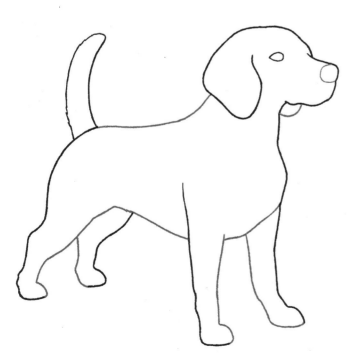

3. Add shapes for the nose and ear. Continue to refine the body shape, back, chest, and front legs. Shape the tummy outline and the rear legs.

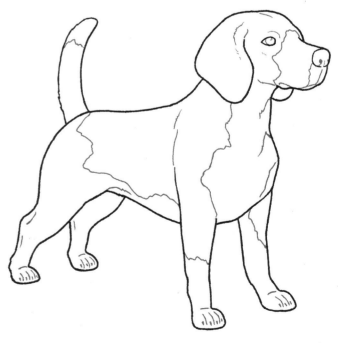

4. Add lines to indicate the color pattern on the fur. Refine the area around the eyes and nose. Detail the paws, and add the toes and nails.

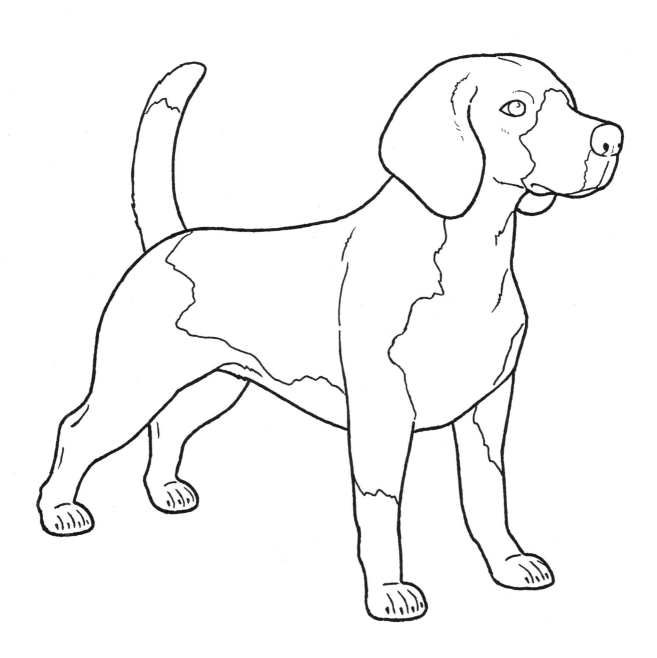

BOXER

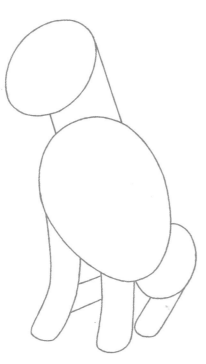

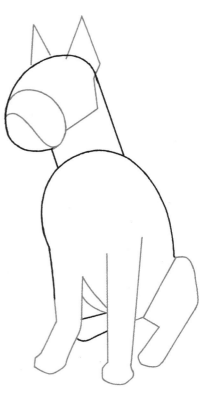

1. First, draw an oval shape for the body, add lines for the neck, and draw another oval shape for the head. Add elongated, curved lines for the front legs and the inner rear leg. Draw an oval for the thigh, then add the second rear leg.

2. Refine the head, and outline the muzzle and the ears. Draw a teardrop shape for the jowls, and define the body and legs.

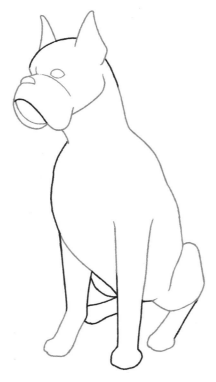

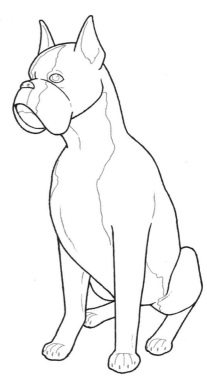

3. Add more detail to the body, the rear legs, and thighs. Add shapes for the eye and nose, and detail the head, mouth, and jawline.

4. Add additional details to the eyes, nose, and ears. Draw in lines indicating the color pattern of the dog's fur, and add contour lines over the neck, chest, and legs. Detail the paws.

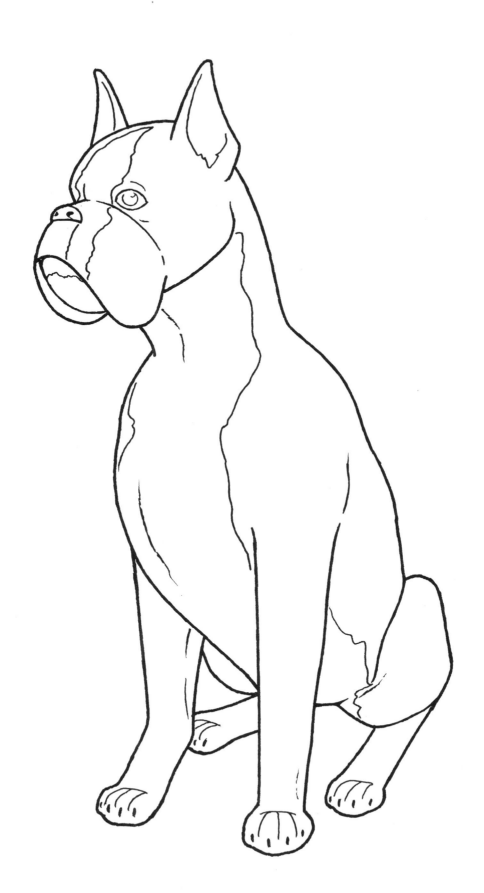

BULLDOG

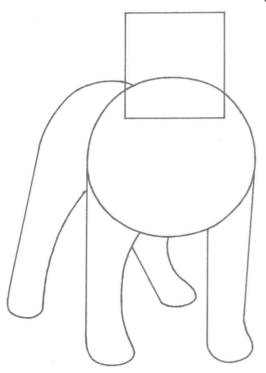

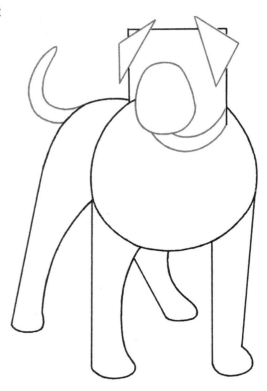

1. Begin with a circular shape for the body, and a square outline for the head. Add elongated oval shapes for the legs.

2. Draw triangular shapes for the ears, and an oval shape for the muzzle. Outline the collar and the tail.

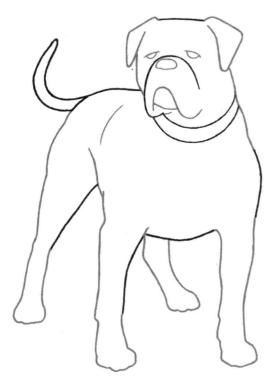

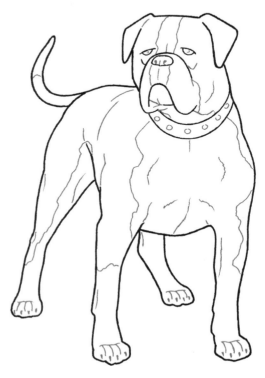

3. Add the dog's eyes and nose. Refine the shape of the jaw and the ears, and add detail to the body shape, legs, and neck.

4. Add detail to the eyes and nose. Add lines on the body to indicate the color pattern in the fur. Draw in the studs on the collar. Finish with feathered lines to indicate body contour.

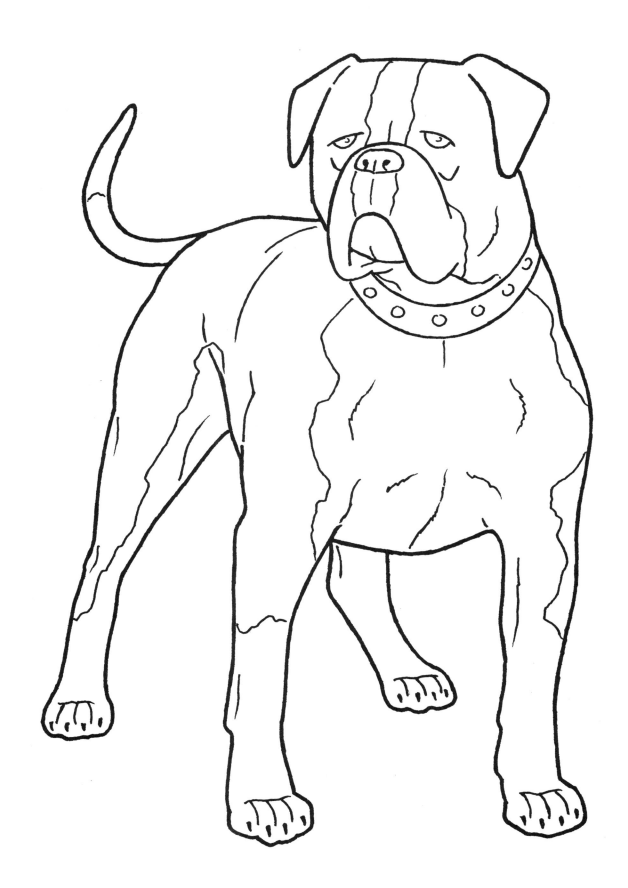

CHIHUAHUA

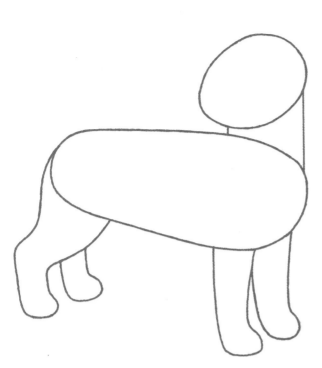

1. Draw a long oval shape for the body. Outline the neck and draw another oval shape for the head, then add shapes for the ears and legs.

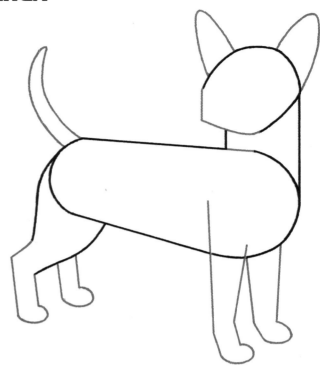

2. Refine the shape of the head, and add the chin and ears. Shape the legs and add the tail.

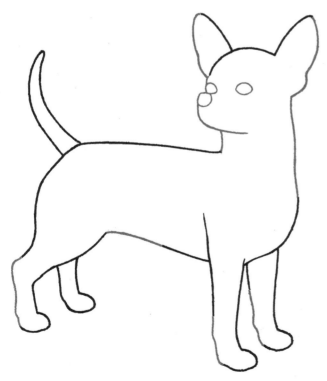

3. Draw in shapes for the eyes and the nose. Continue to refine the outline of the neck, tummy, and legs.

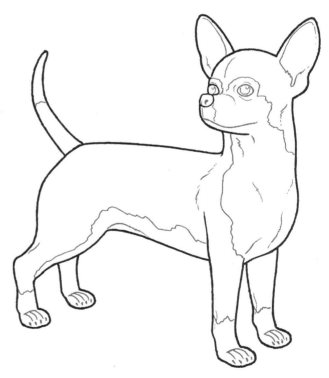

4. Detail the area around the eyes, nose, and mouth. Add contour lines to the ears, neck, chest, and tummy. Add toes and nails, and finish with lines indicating color pattern and markings on the fur.

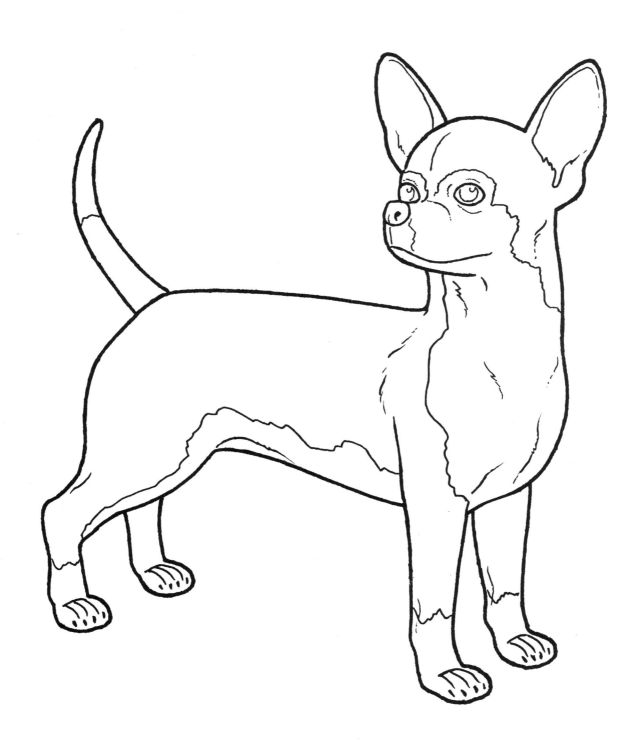

COCKER SPANIEL

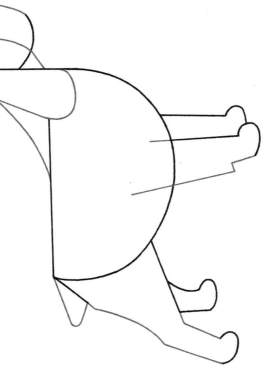

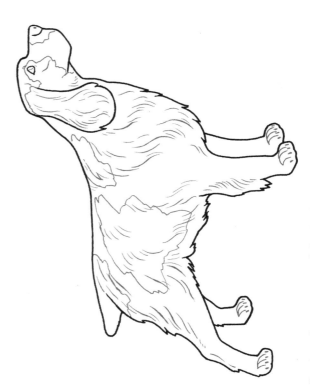

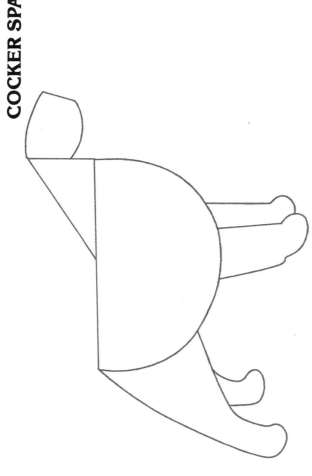

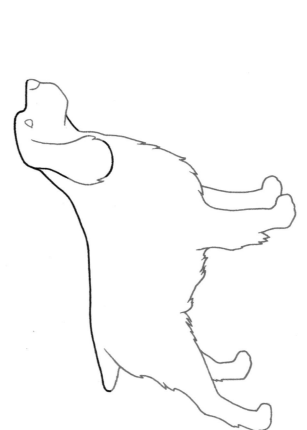

1. Draw a half oval shape for the main body, and outline the neck and head. Draw in shapes for the legs.

2. Refine the shape of the head and neck. Add shapes for the ear and the tail. Refine the legs.

3. Draw in shapes for the eye and nose, and define the ear. Continue to refine the tummy, rear, and legs. Add feathering to the body and legs to represent long hair.

4. Following the contour of the body, add lines to represent the dog's long wavy hair. Draw in outlines for color markings and add detail to the paws. Finish by detailing the eyes and nose.

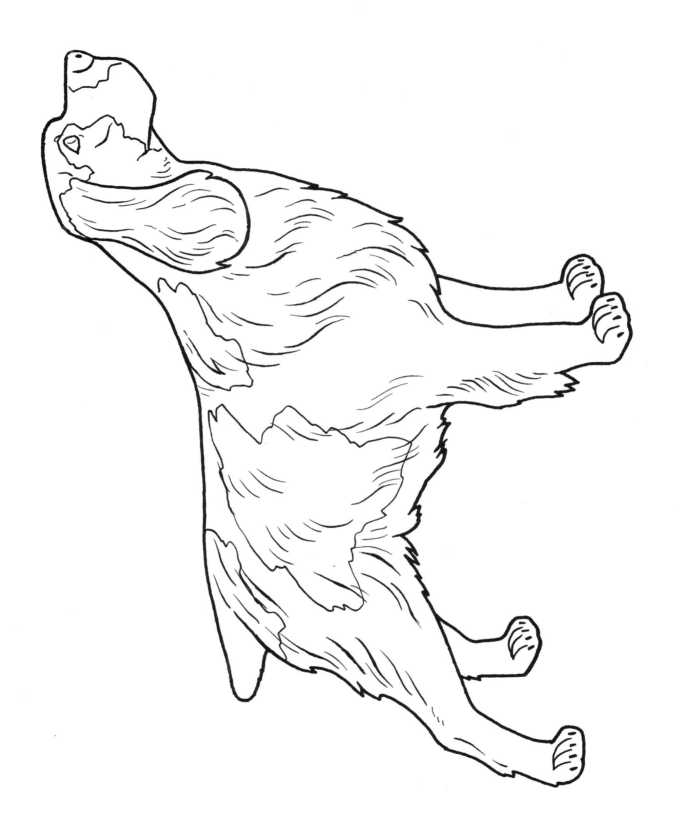

DACHSHUND

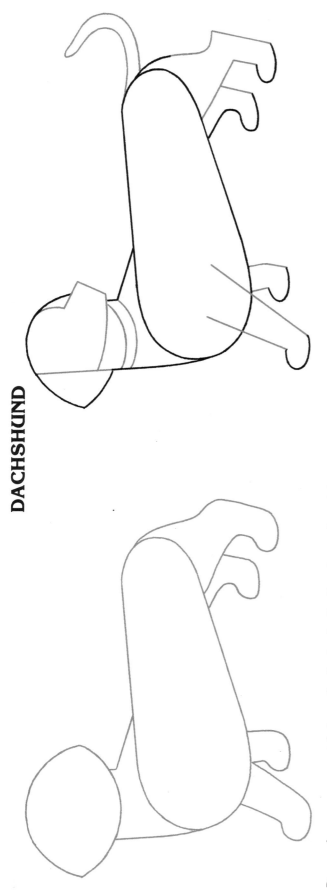

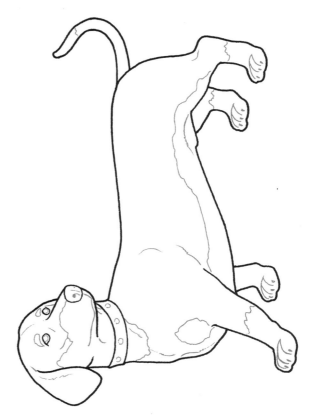

1. Draw a long, narrow, oval shape for the body. Outline the neck and draw a pointed oval for the head. Add short, curved shapes for the legs.

2. Refine the head, neck, and jaw. Add in the shape for the collar. Shape the legs and paws, and outline the tail.

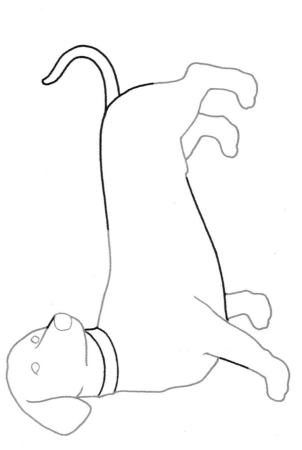

3. Refine the shape of the body by adding curves to the dog's back, chest, legs, and paws. Refine the shape of the ears and the jaw. Add shapes for the eyes and nose.

4. Detail the area around the eyes, nose, and mouth. Add contour lines to the ears, neck, chest, and tummy. Draw in lines indicating the color pattern and markings on the dog's fur.

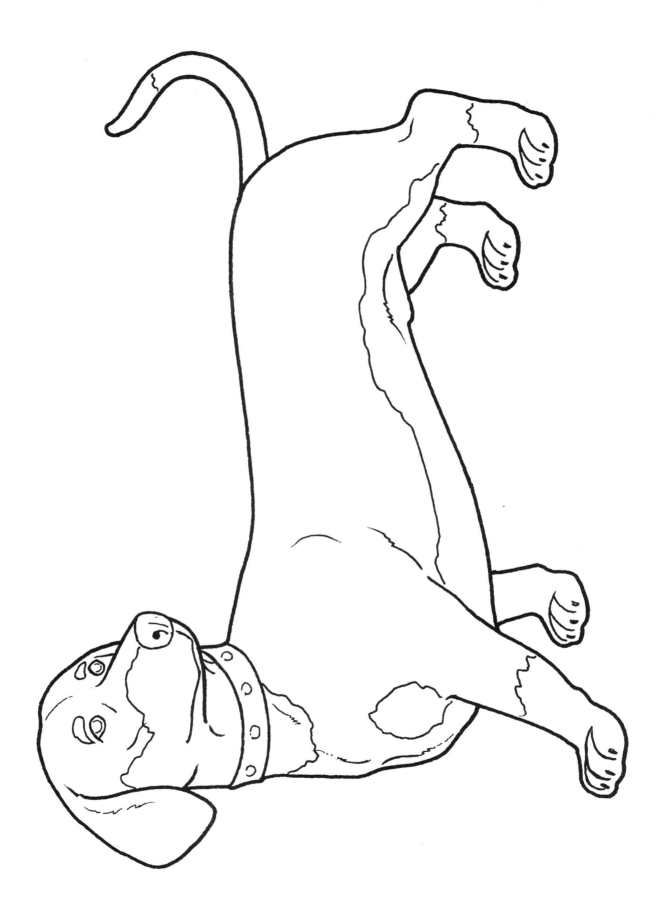

GERMAN SHEPHERD

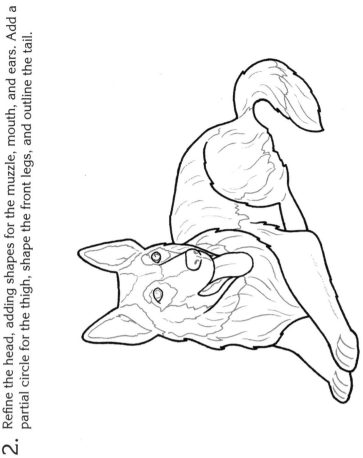

1. Draw a half oval shape for the chest, and add elongated lines to represent the front legs. Draw an oval for the head, and outline the main body.

2. Refine the head, adding shapes for the muzzle, mouth, and ears. Add a partial circle for the thigh, shape the front legs, and outline the tail.

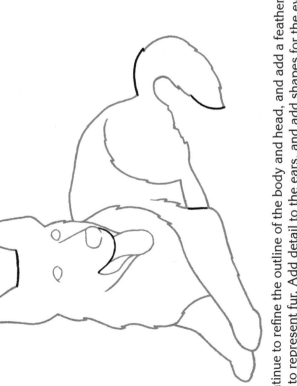

3. Continue to refine the outline of the body and head, and add a feathered line to represent fur. Add detail to the ears, and add shapes for the eyes and nose. Refine the muzzle and jaw, and add the tongue.

4. Add details to the eyes and nose. Draw lines to indicate the color patterns in the dog's fur. Detail the paws, and draw in some lines to represent the color patterns on the fur.

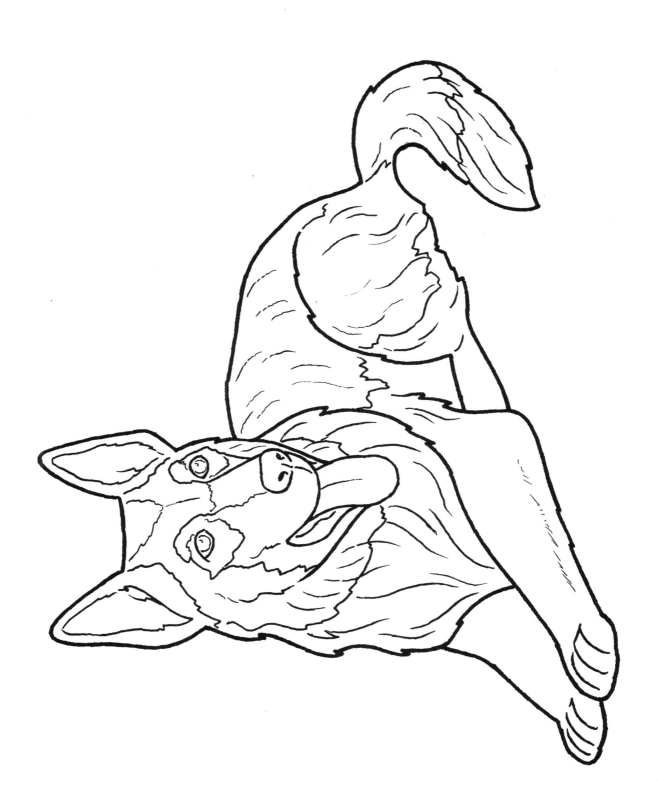

GOLDEN RETRIEVER

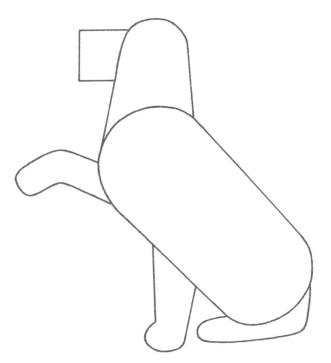

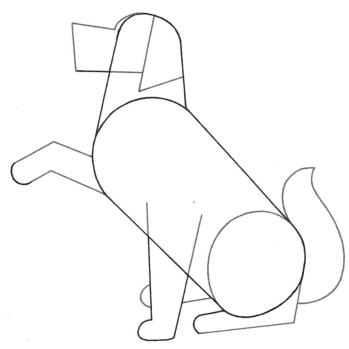

1. Begin by drawing a long oval shape for the body. Add a curved outline for the neck and head, and a square shape for the muzzle. Draw a curved shape for the raised paw; add the second front leg and the rear leg.

2. Refine the shape of the head and muzzle, and add the ear. Shape the raised paw. Add shapes for the rear leg, thigh, and tail.

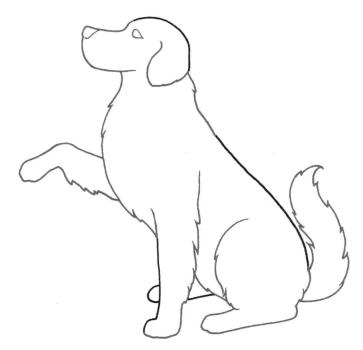

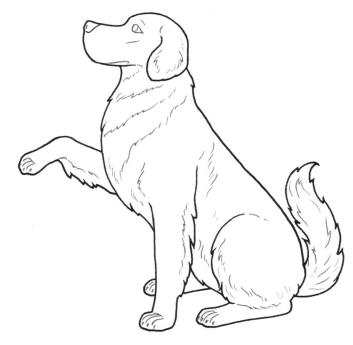

3. Refine the outline of the body, and continue to add detail to the legs, the thigh, and paws, emphasizing the feathered outline. Add shapes for the nose and the eye.

4. Add more detail to the nose and eye. Draw the mouth and expression lines above and below eyes. Draw in feathered lines for the fur, and finish off by adding detail to the toes and nails.

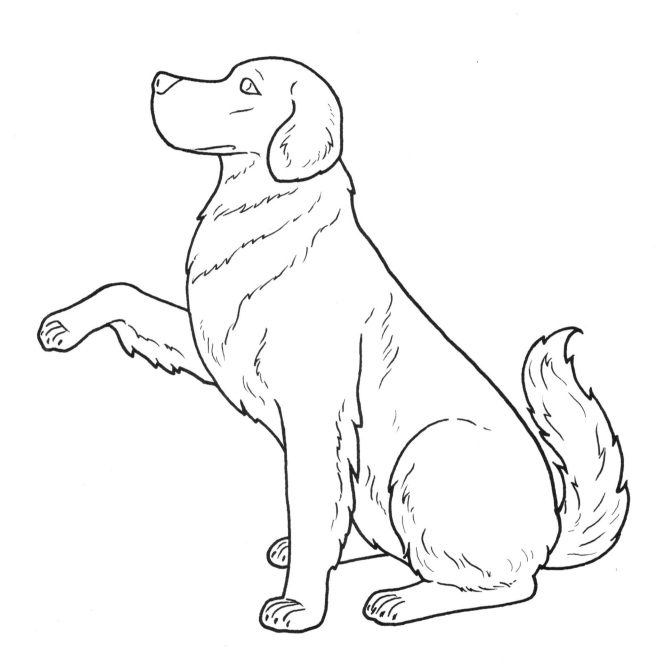

GREAT DANE

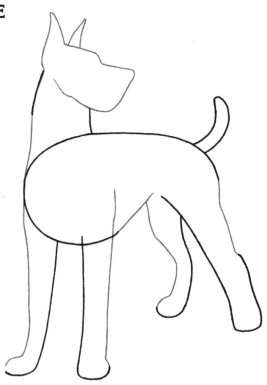

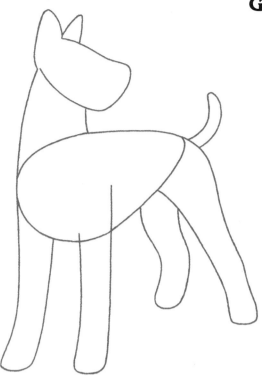

1. Draw a pear shape for the main body. Add lines for the neck, and shape the head and ears. Outline the rear legs, and then draw shapes for the front legs. (Make sure the front legs are a little longer than the rear legs.) Add a curved shape for the tail.

2. Refine the outline of the head, taking care around the ears and chin. Define the legs and the outline of the tummy.

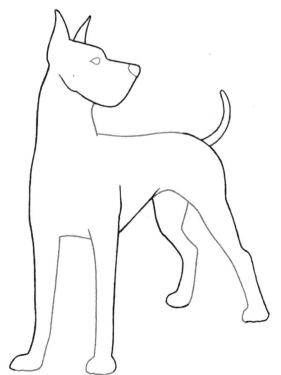

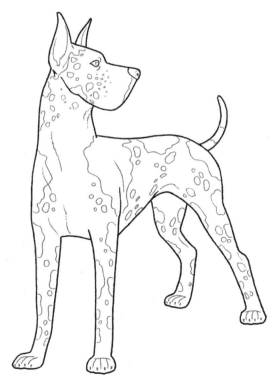

3. Add shapes for the eye and the nose, and continue to refine the body outline and the legs.

4. Add more detail to the ears, eyes, and nose. Draw contour lines on the neck, chest, and stomach. Finish by drawing large and small shapes for the spots and detail the toes and nails.

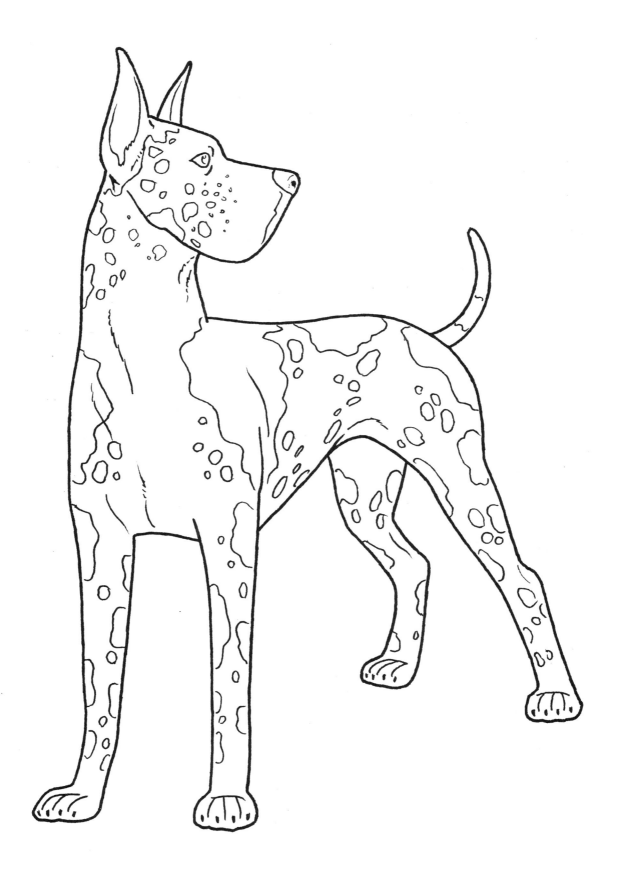

LABRADOR RETRIEVER

1. Draw a pear shape for the main body. Add outlines for the neck, head, and legs.

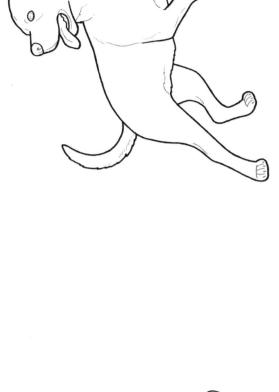

2. Refine the shape of the dog's head, and add a triangular shape for the ear. Refine the outline of the legs, and add the tail.

3. Draw in the nose and the eye. Shape the mouth and tongue. Detail the body shape and legs, adding muscular curves. Add feathered lines to the chest, tail, and tummy to indicate fur.

4. Detail the area around the eyes, nose, mouth, and jaw. Add contour lines to the head, neck, chest, and shoulders. Finish by drawing in the toes and nails.

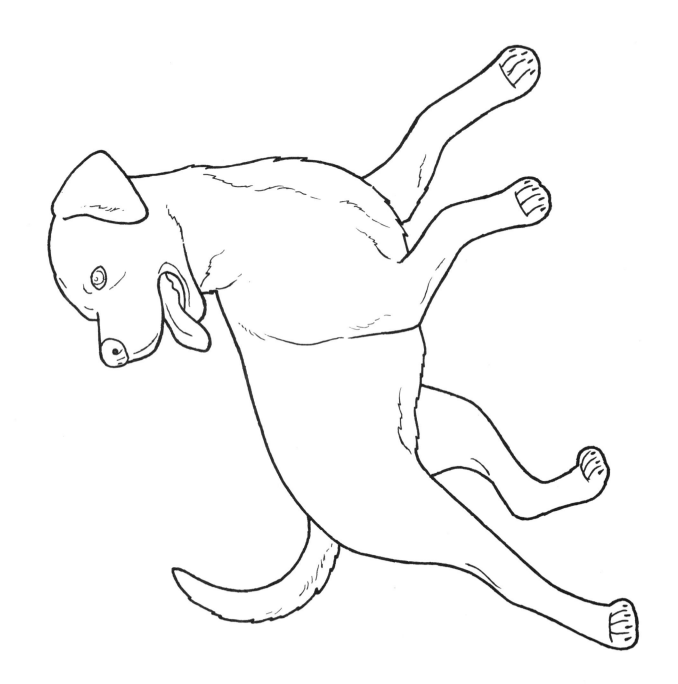

POODLE

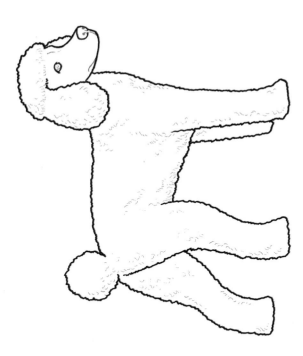

1. Draw a rectangular shape for the body. Outline the shape of the head, and draw elongated, curved shapes for the legs.

2. Outline the shape of the face and jaw. Add an oval shape for the ears, and a rough circle for the tail. Refine the shape of the chest.

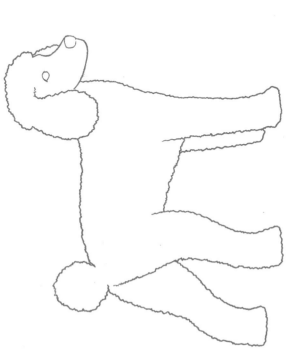

3. Draw in the eye and nose, and outline the entire body with an irregular line to represent curly hair.

4. Draw in the mouth, and detail to the eyes and nose. Finish with short curvy strokes to represent tight curly hair.

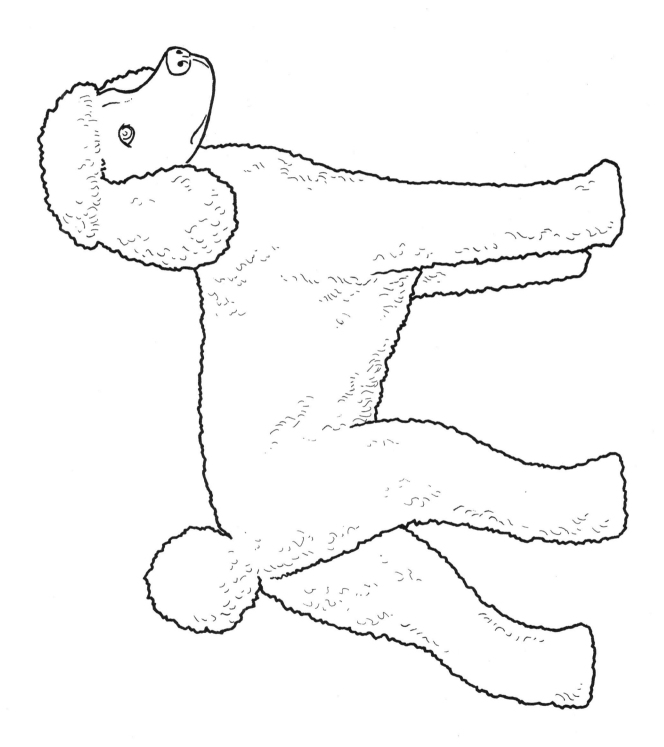

PUG

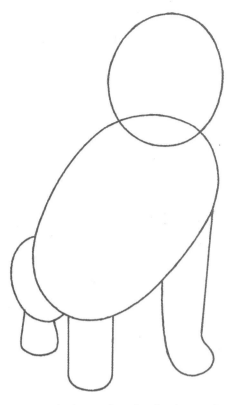

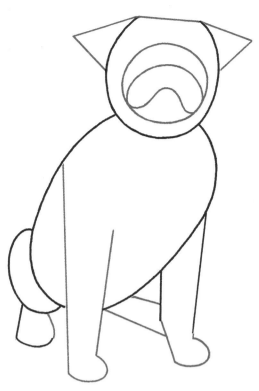

1. Draw an oval shape for the body, and a smaller oval for the head. Draw another oval for the rear thigh and outline the rear paw. Add elongated oval shapes for the front legs.

2. Refine the outline of the head. Shape the ears, and draw in a curved sausage shape to outline the mouth.

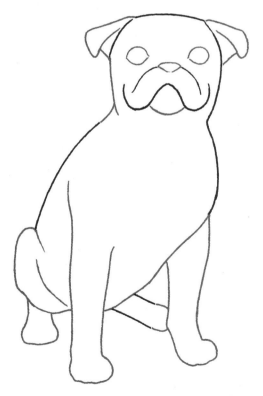

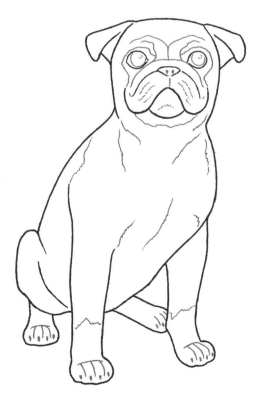

3. Draw in the eyes and the lower part of the ears. Add the chin. Refine the outline of the dog's tummy and legs.

4. Add detail to the eyes and nose, and draw the fold lines on the head and around the eyes. Add broken lines to the muzzle. Draw lines for the color pattern on the lower part of the front legs and finish with detail to the paws.

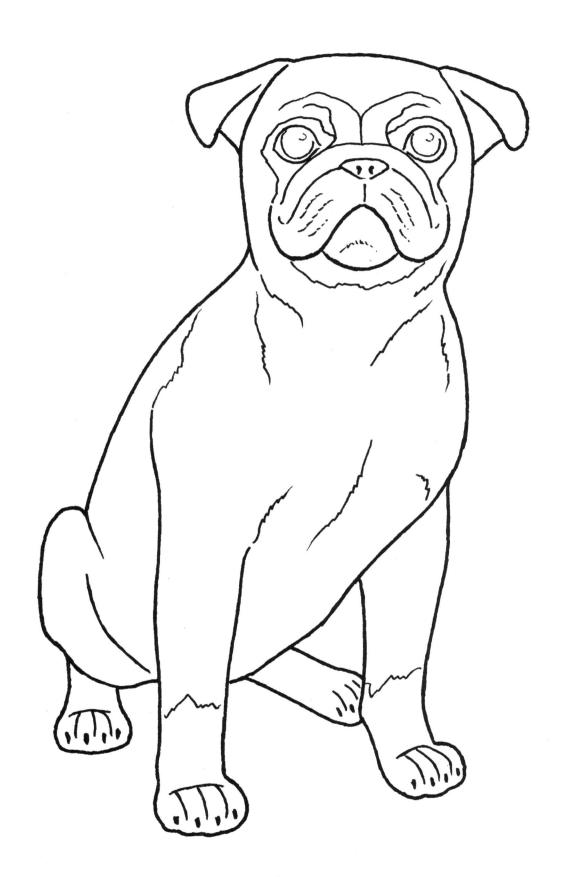

SCHNAUZER (MINIATURE)

1. Draw a rectangular shape for the main body and outline the head and the legs.

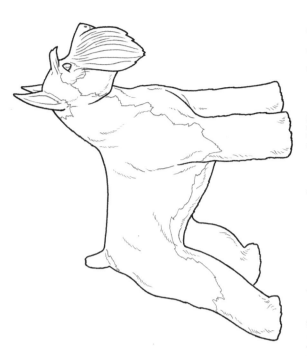

2. Refine the shape of the head, and add the ears. Outline the eyebrows and side whiskers. Detail the chest, back, tail, and the legs.

3. Continue to refine the eyebrows, side whiskers, and the chin; draw in the eye. Refine the outline of the neck, legs, back, chest, and tummy.

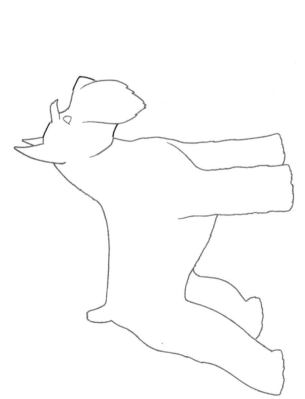

4. Add details to the ears, eye, and nose. Add lines on the body to indicate the color pattern in the fur. Finally, add contour lines with short, feathered strokes.

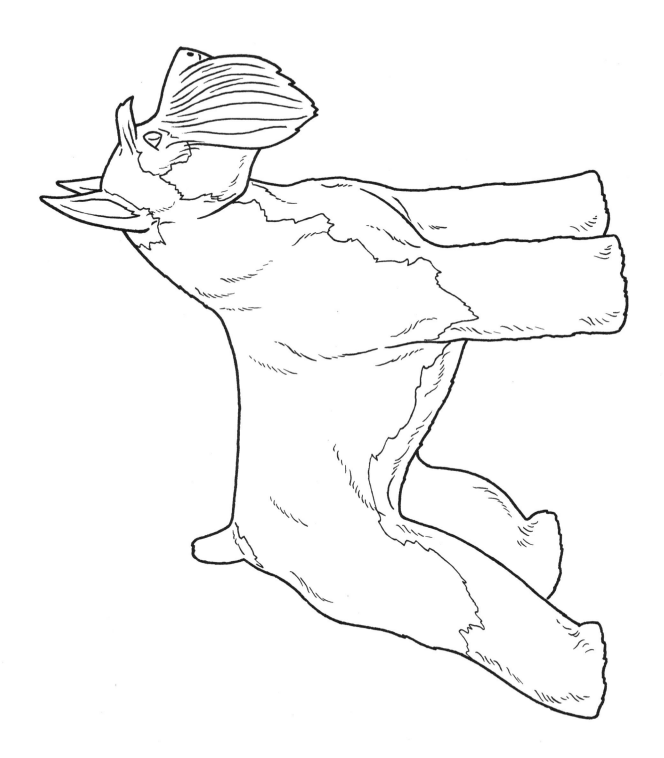

SHIH TZU

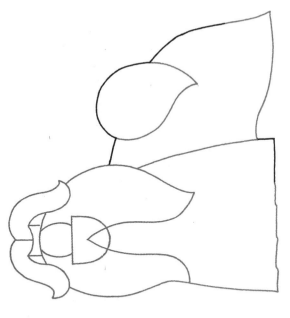

1. Begin by drawing a pointed oval shape for the body. Add rectangular shapes for the face and the chest. Add a small half circle for the tail.

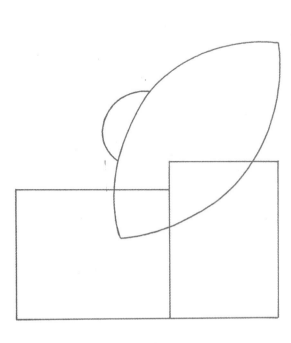

3. Add shapes for the eyes and nose, and outline the mouth. Detail the center part of the bow, and add lines to represent the long facial hair. Draw more lines for the long body hair and refine the shape of the tail, adding a feathered outline to the rear base line.

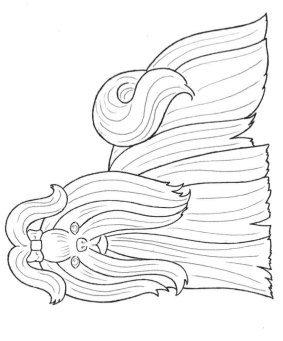

2. Refine the outline of the body, and add a feathered outline to the baseline of the chest. Add a curved, horseshoe shape for the head and facial fringes. Draw in the outline of the top-knot, bow, and tail.

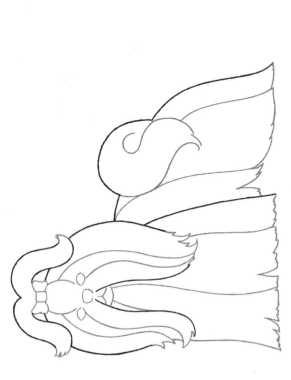

4. Following the contour of the body, add more lines to represent the long body hair. Add detail to the eyes, nose, and the bow.

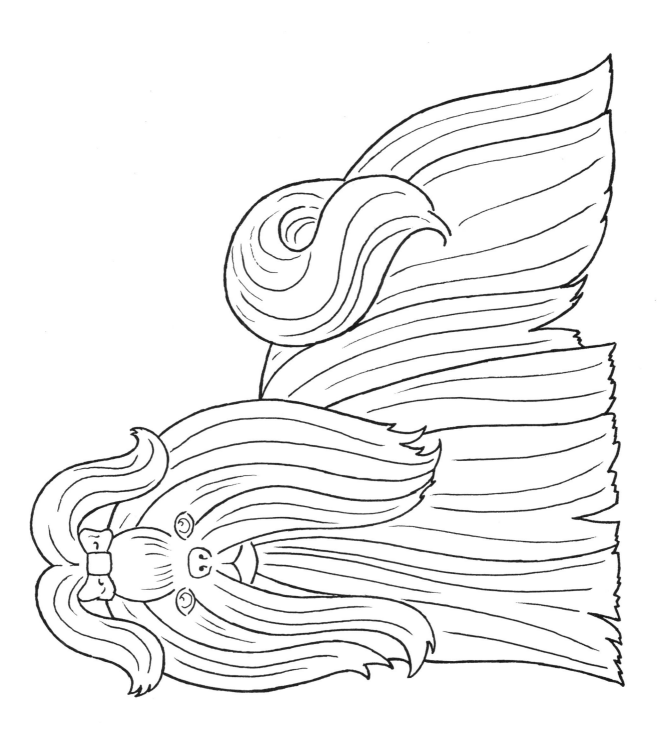

YORKSHIRE TERRIER

1. Draw rectangular shapes to outline the body and the head. Draw partial circles for the face and the tail.

2. Refine the outline of the head and add elongated curved shapes for the facial fringes. Shape the muzzle and the facial fur, and outline the shape of the bow and the top-knot. Draw a curved outline to represent the dog's chest, and add feathering to the baseline. Refine the tail.

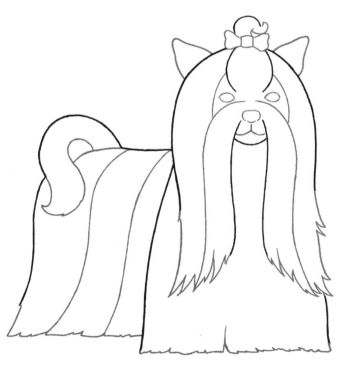

3. Outline the mouth and chin, and add shapes for the eyes and nose. Refine the top-knot and the bow. Draw contour lines to represent the dog's long hair, and add more feathering to the baseline.

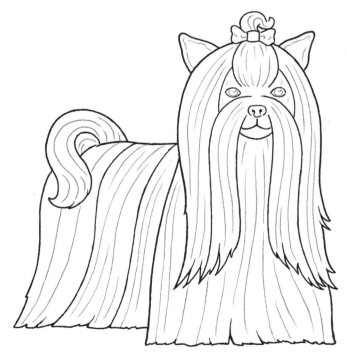

4. Add more detail to the hair, making sure that all lines follow the contour of the body. Refine the eyes, nose, and bow.

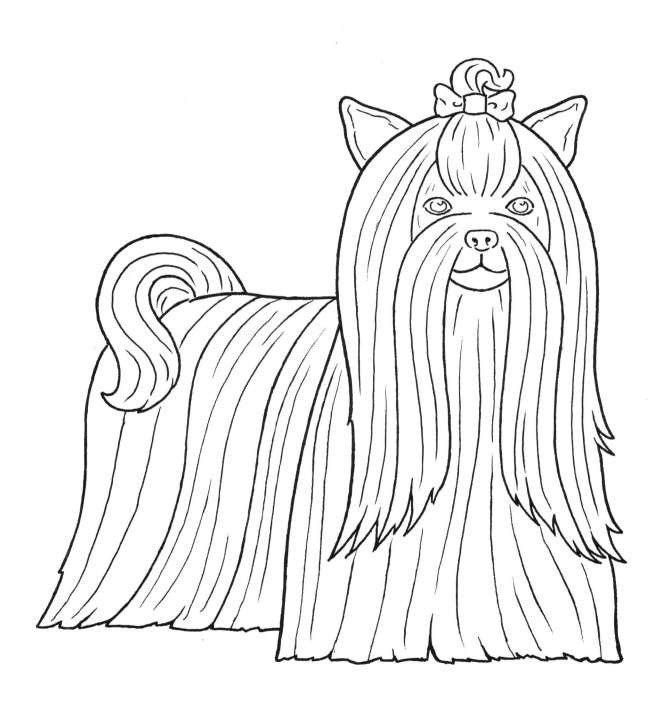